Japanese Floral Patterns

and Motifs

Madeleine Orban-Szontagh

Dover Publications, Inc., New York

Copyright © 1990 by Dover Publications, Inc.
All rights reserved under Pan American and International Copyright Conventions.

Published in Canada by General Publishing Company, Ltd., 30 Lesmill Road, Don Mills, Toronto, Ontario.
Published in the United Kingdom by Constable and Company, Ltd., 10 Orange Street, London WC2H 7EG.

Japanese Floral Patterns and Motifs is a new work, first published by Dover Publications, Inc., in 1990.

DOVER *Pictorial Archive* SERIES

Manufactured in the United States of America
Dover Publications, Inc., 31 East 2nd Street, Mineola, N.Y. 11501

Library of Congress Cataloging-in-Publication Data

Orban-Szontagh, Madeleine.
 Japanese floral patterns and motifs / Madeleine Orban-Szontagh.
 p. cm. — (Dover pictorial archive series)
 ISBN 0-486-26330-4
 1. Decoration and ornament—Plant forms—Japan—Themes, motives. I. Title. II. Series.
NK1484.A107 1990
745.4′4952—dc20 90-33319
 CIP

Publisher's Note

Japan is one of the handful of countries in which the arts of decoration have been cultivated with the greatest care, ingenuity and taste. The world of plants and flowers has furnished innumerable elements in the ornamentation of clothing, furniture and objects of everyday use, as well as works of architecture, sculpture and painting.

The present collection of patterns and motifs has been rendered by the noted surface artist Madeleine Orban-Szontagh from original costumes, screens, boxes and other furnishings dating from the sixteenth through the nineteenth centuries. Each page represents a significant detail of the entire original design. Each is a creative adaptation, in the spirit of the original, rather than a slavish copy. The result in every case is a self-standing artistic page, with designs more immediately adaptable to a variety of decorative uses (a design originally on fabric, for instance, can be used on any flat surface, for leather tooling, etc.).

Some of the florals are abstract or generalized, but a number of specific flowers and plants are immediately recognizable. These include: bamboo (page 7), chrysanthemums (21), lilies (6), gourds (with wheels, 16), hydrangeas (37), irises (43), pampas grass (28), paulownias (31; with arrows, 18; with phoenixes, 42), peonies (32; 46; with "rotating commas," 19), plum blossoms (26; 44), willows (30), wistaria (with pines, 9) and wood-sorrel leaves (41).

Three terms in the captions may be unfamiliar. Noh costumes were made to be worn in Noh plays, a hieratic, Buddhist-tinged form of theater that was fostered by the samurai class in the fourteenth century and still delights connoisseurs today. The *kosode* (literally "small sleeves"), basically the same as the modern kimono, arose as a simpler, lighter and looser form of outer garment than the old court robes, after the aristocracy had ceded its power to the new military class in the wake of the great twelfth-century civil wars. The *kosode* later became popular among all classes in the nation. The *katabira* (page 10) was a summer garment of bleached hemp worn by ladies of high rank.

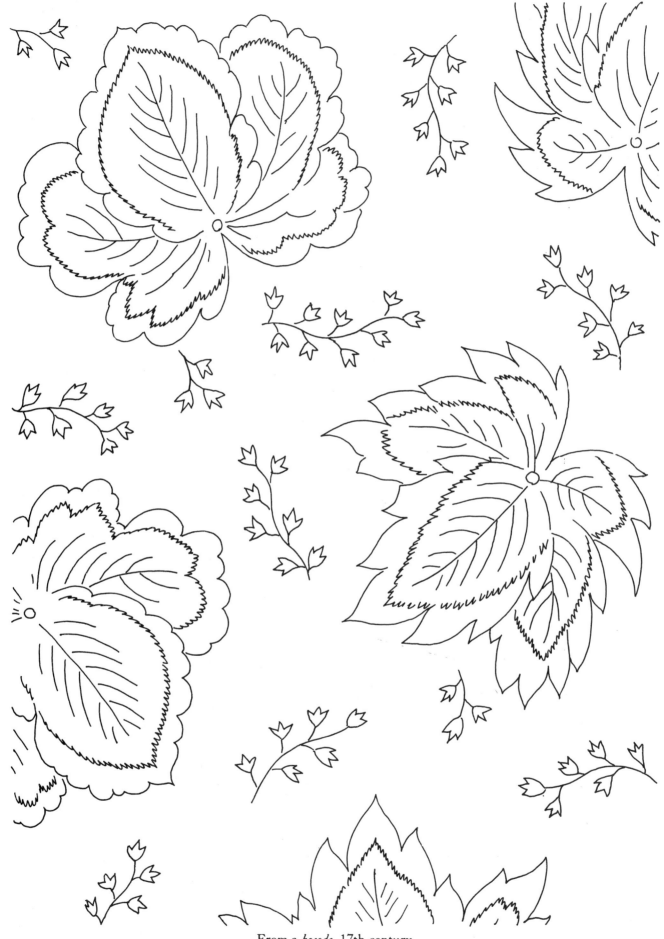

From a *kosode*, 17th century.

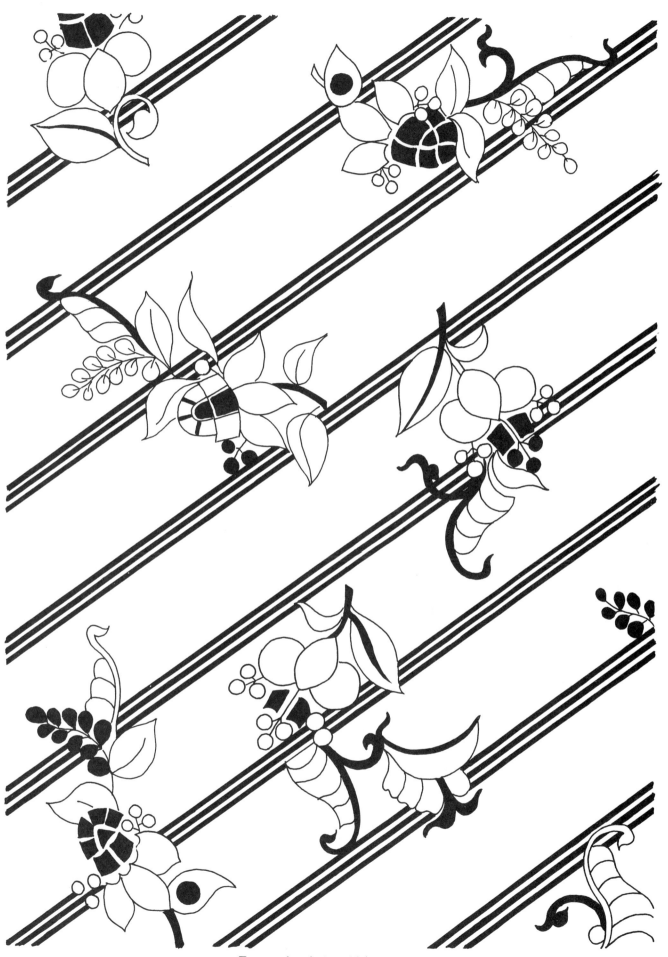

From a *kosode*, late 16th century.

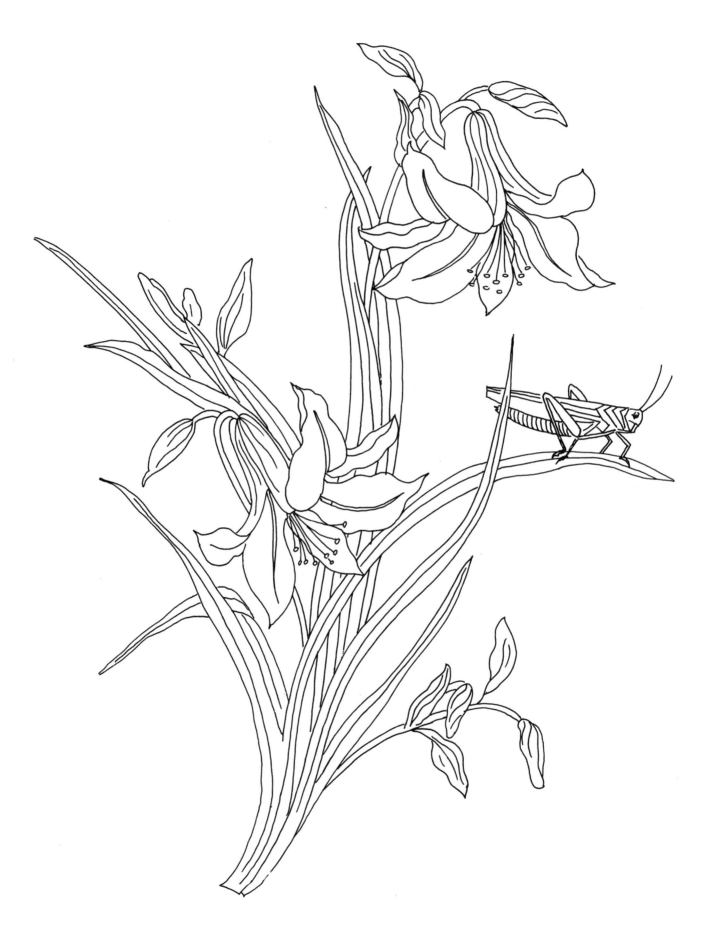

From a watercolor, 18th century.

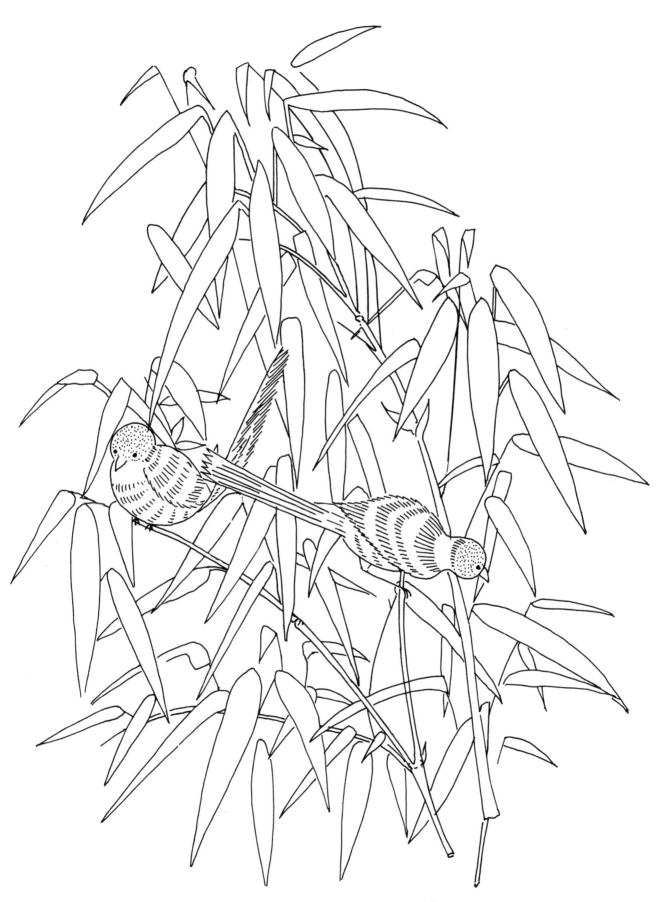

From a wall hanging, 18th century.

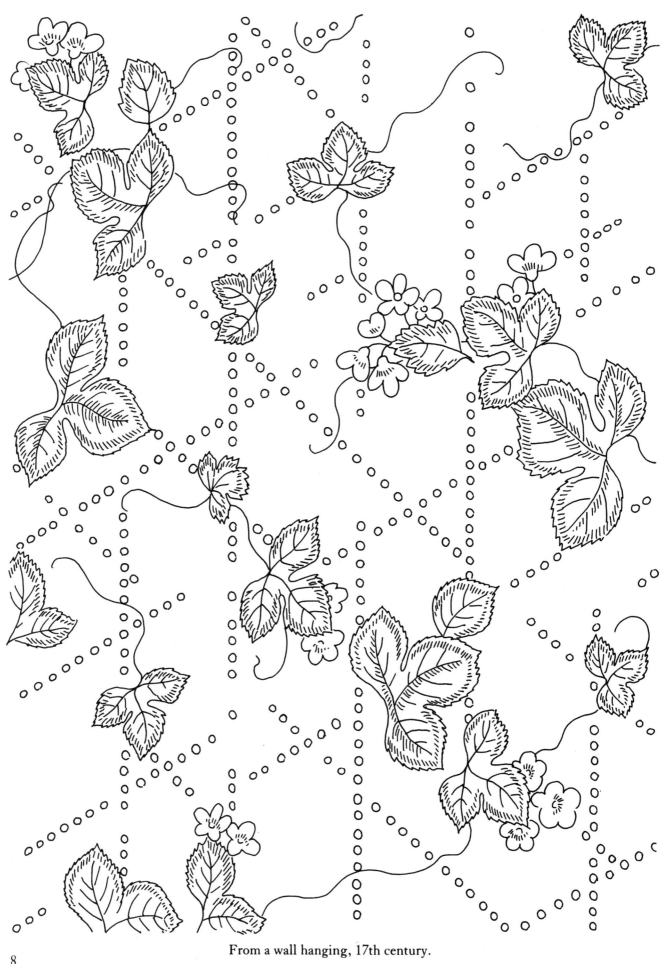

From a wall hanging, 17th century.

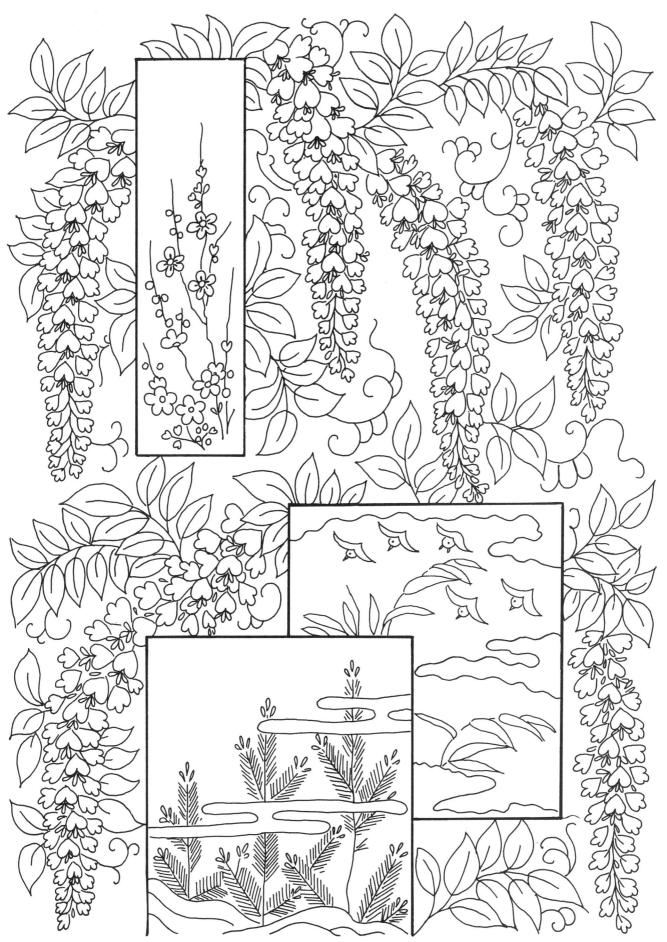

From a Noh costume, 18th century.

9

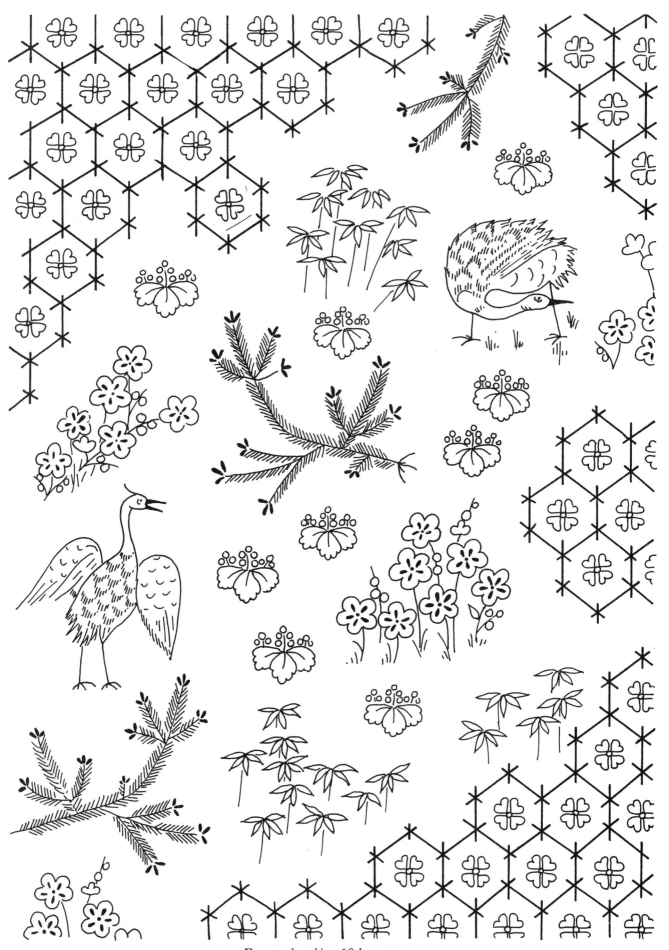

From a *katabira*, 18th century.

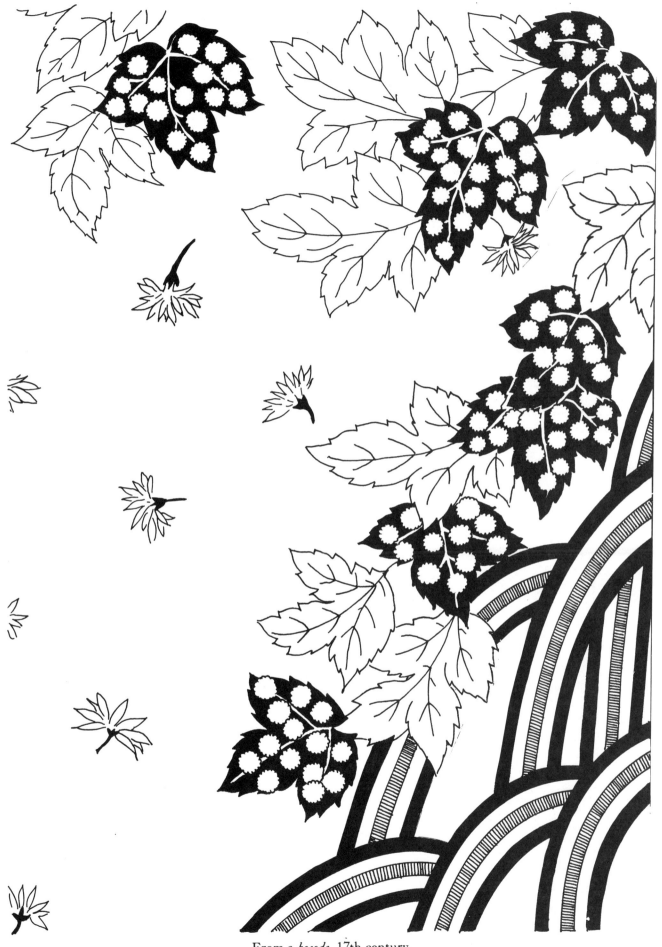

From a *kosode*, 17th century.

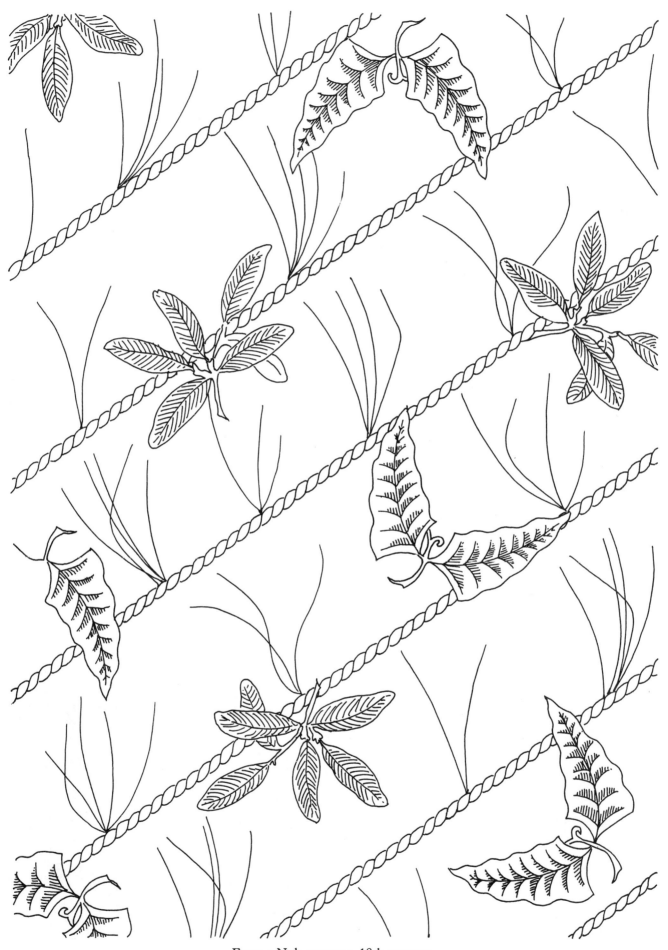

From a Noh costume, 18th century.

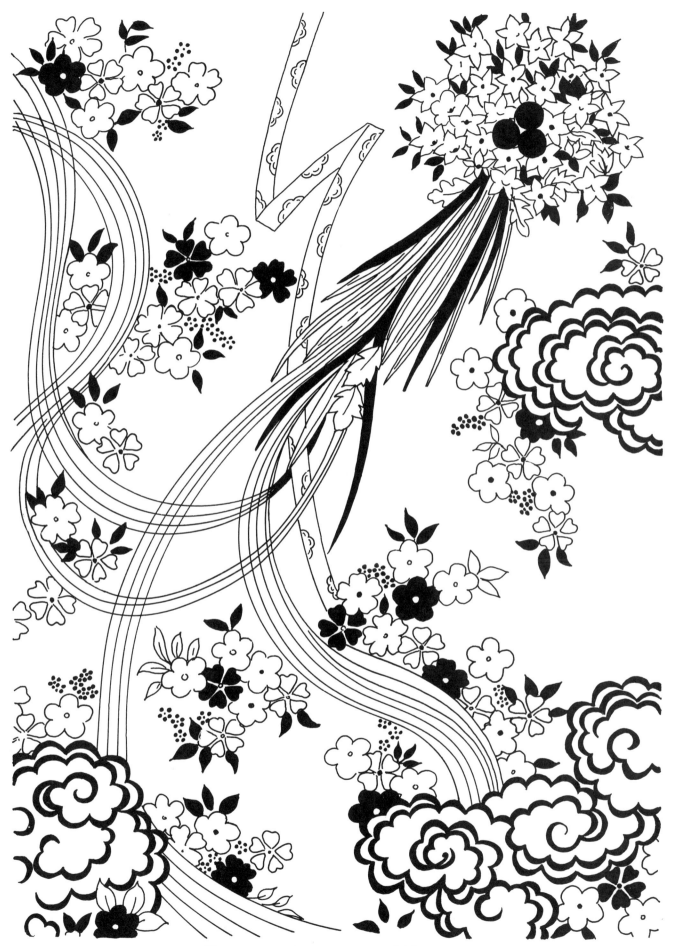

From a woman's outer garment, 18th century.

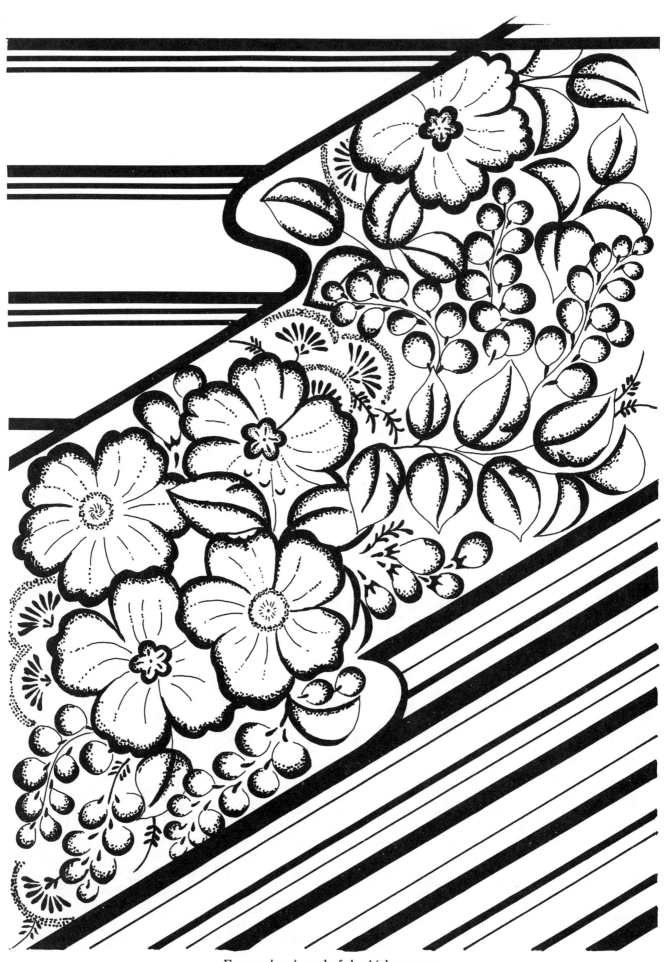

From a *kosode*, end of the 16th century.

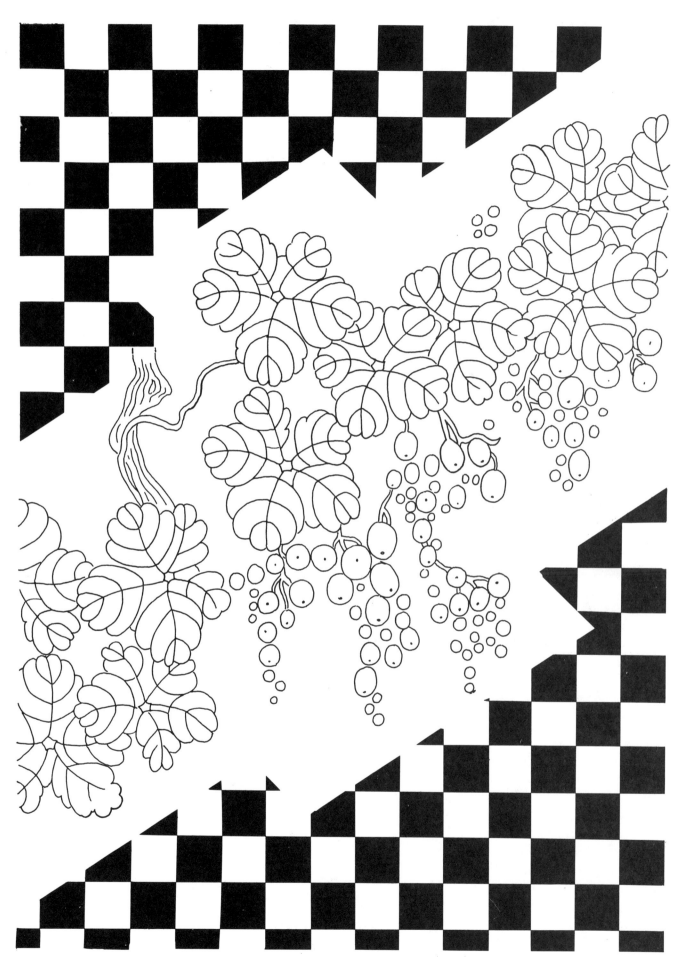

From a Noh costume, end of the 16th century.

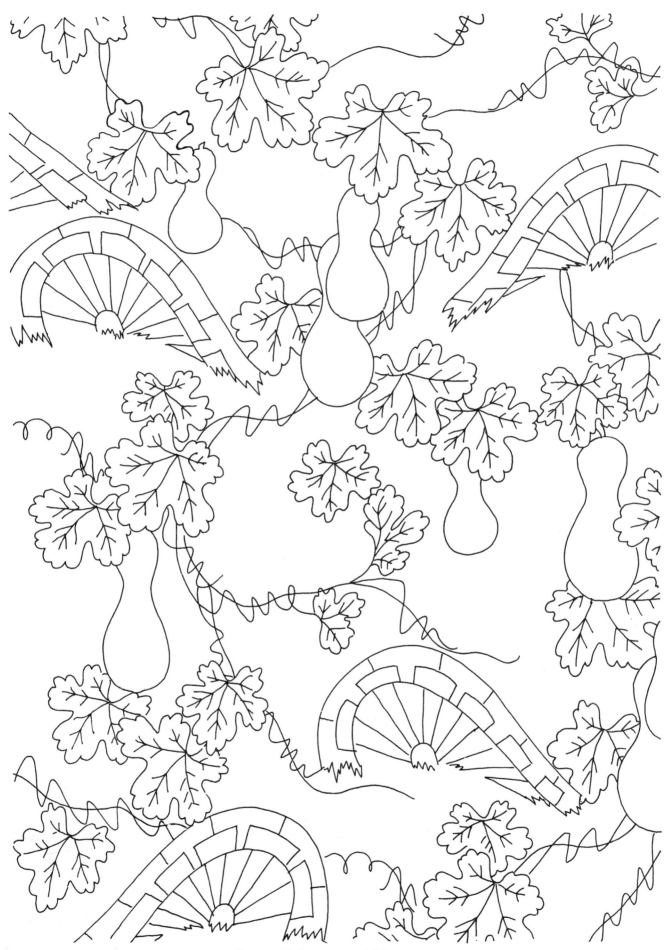

From a Noh costume, 18th century.

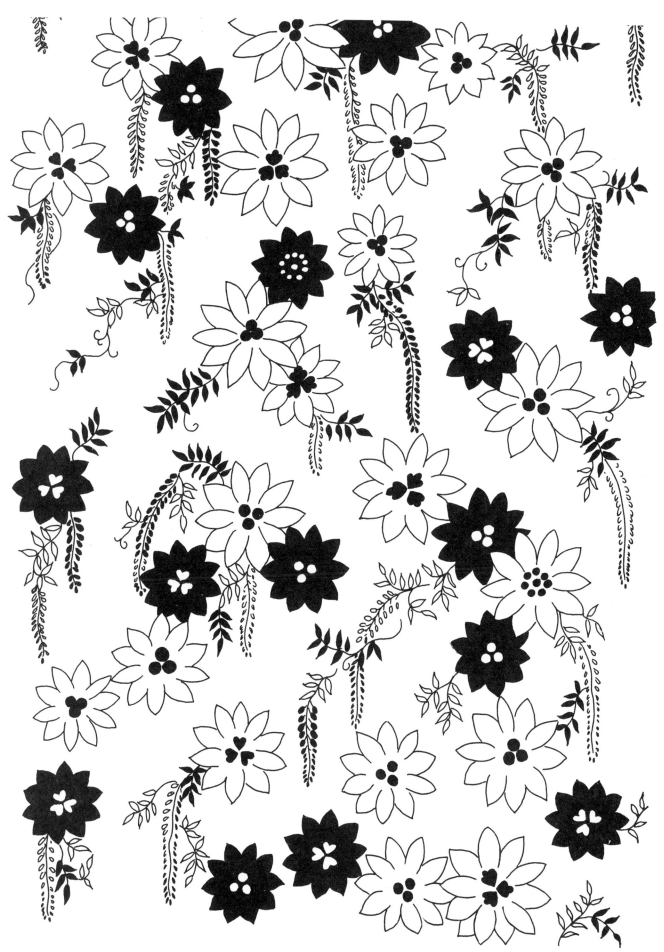

From a *kosode*, 17th century.

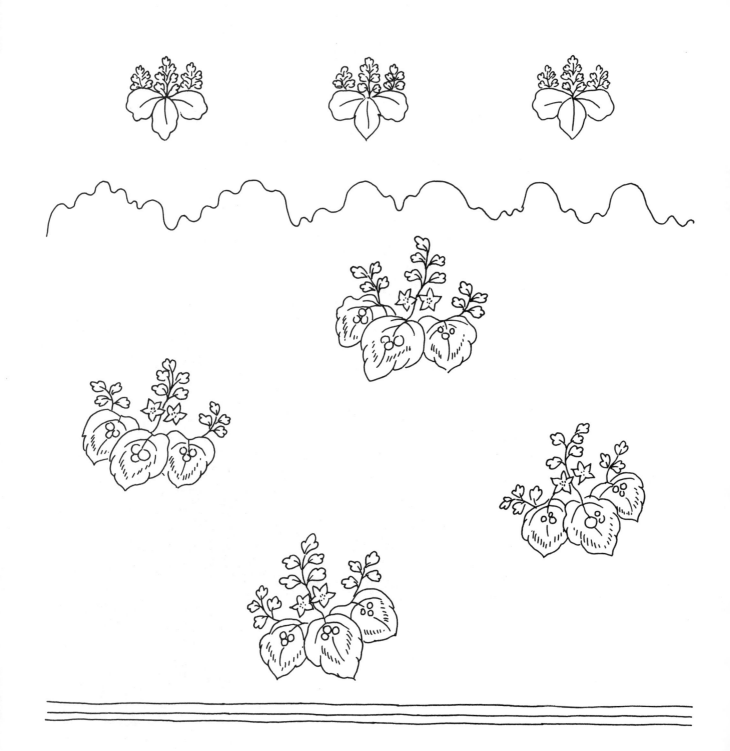

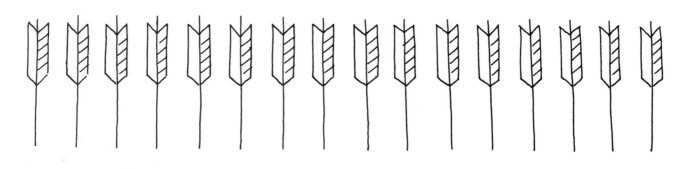

From a *kosode*, late 16th century.

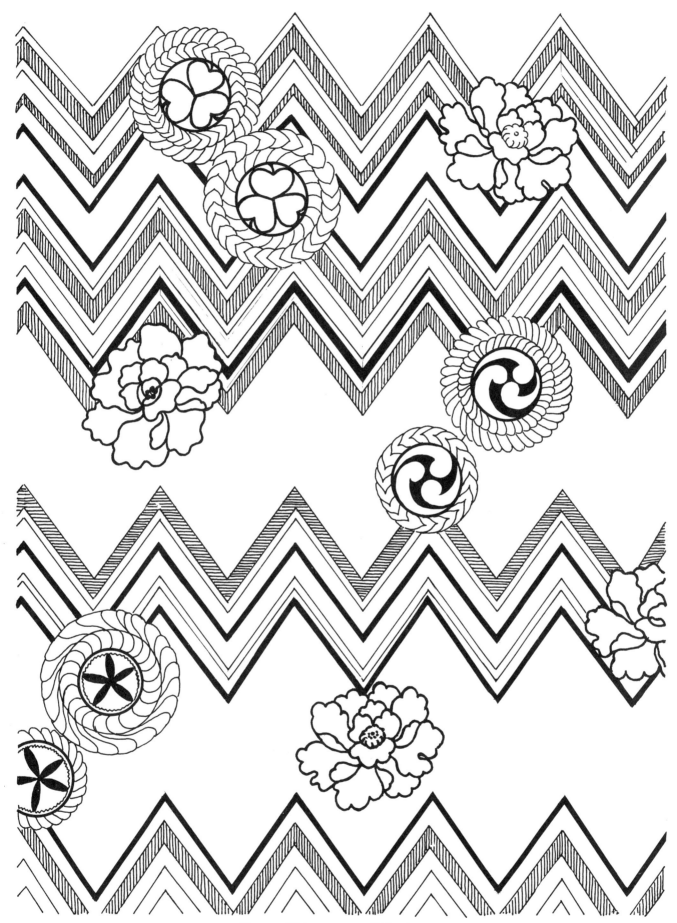

From a Noh costume, 18th century.

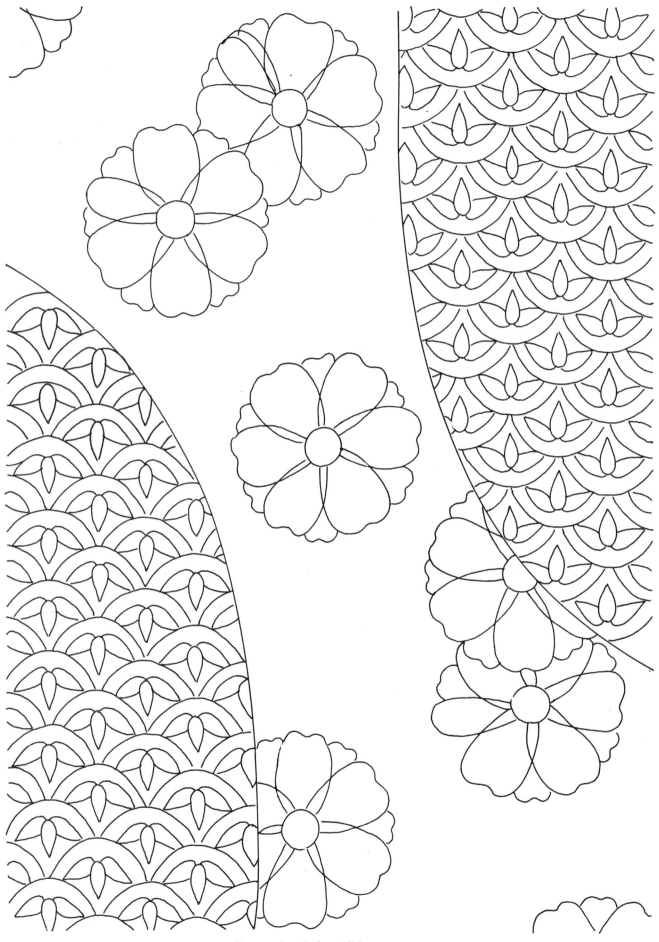

From a *kosode*, late 17th century.

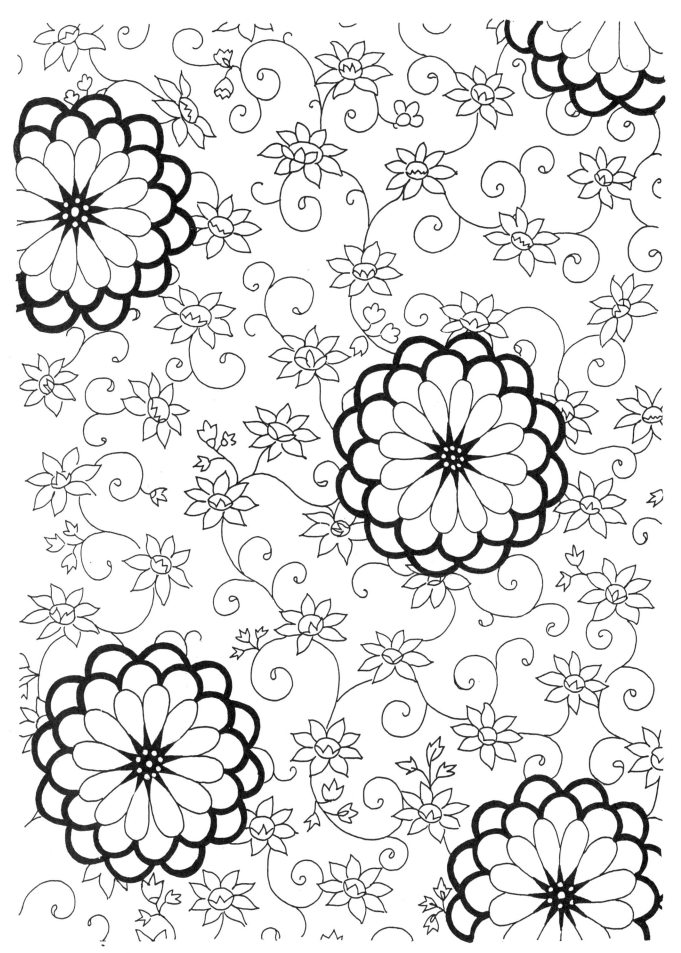

From a Noh costume, 17th century.

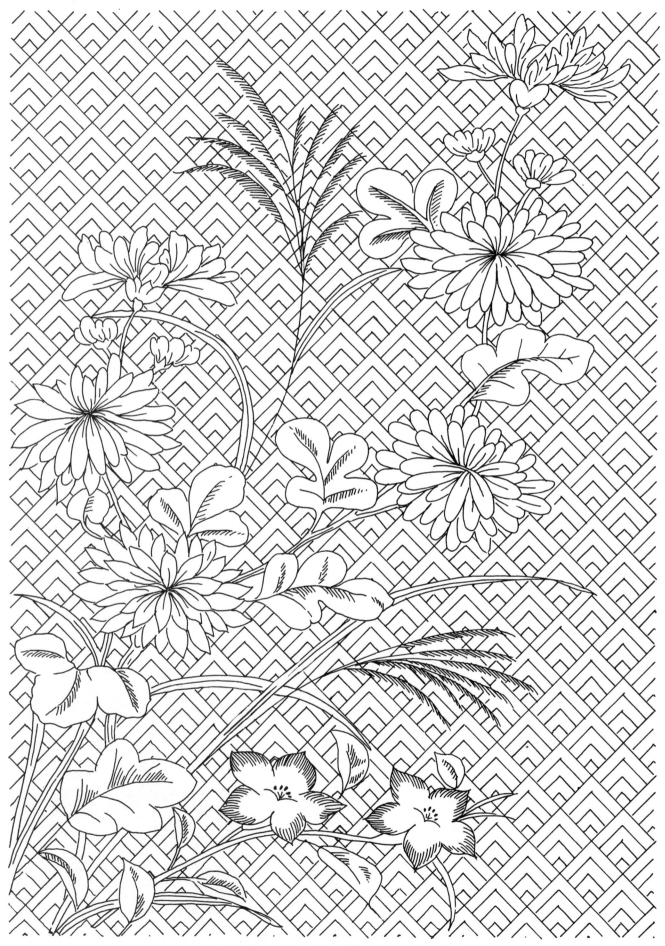

From a screen, 18th century.

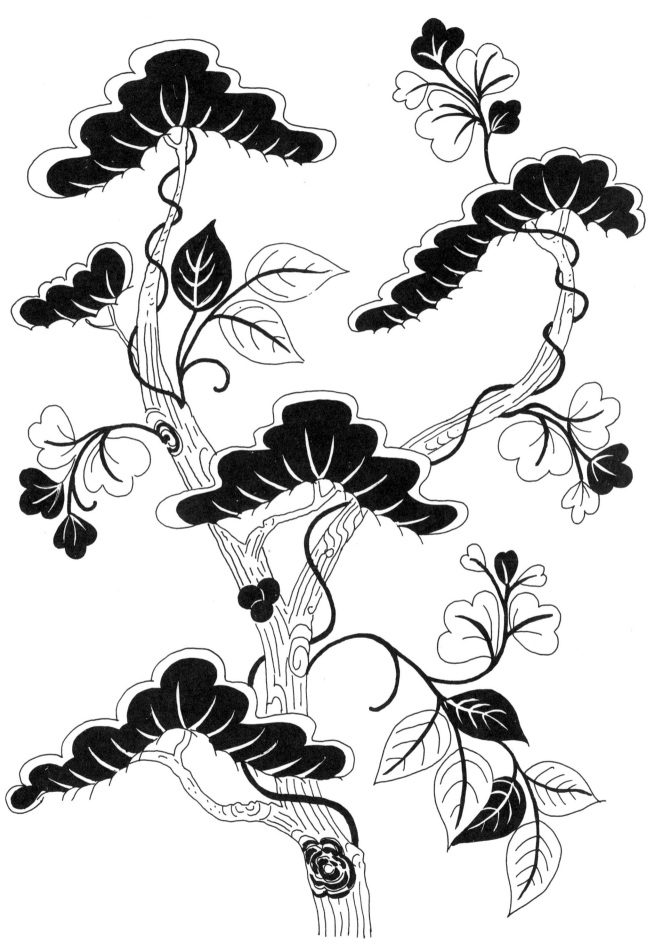

From a Noh costume, end of the 16th century.

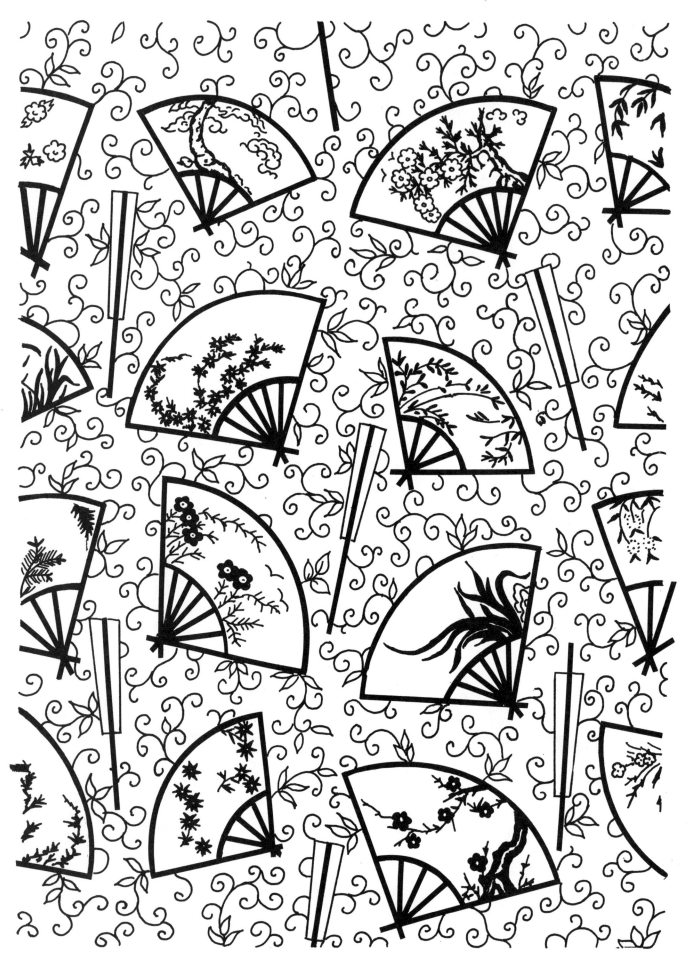

From a Noh costume, 17th century.

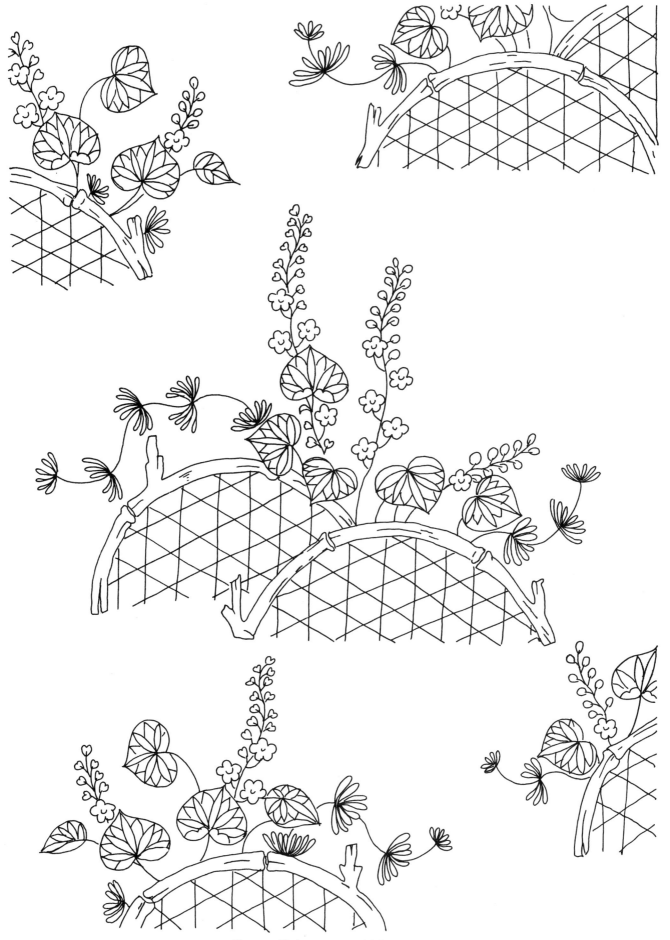

From a Noh costume, 18th century.

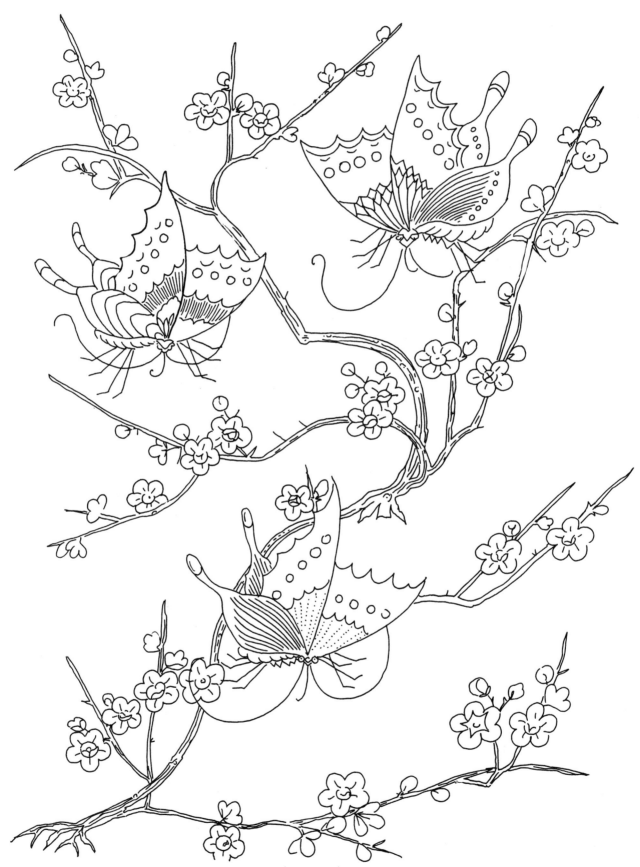

From a Noh costume, 18th century.

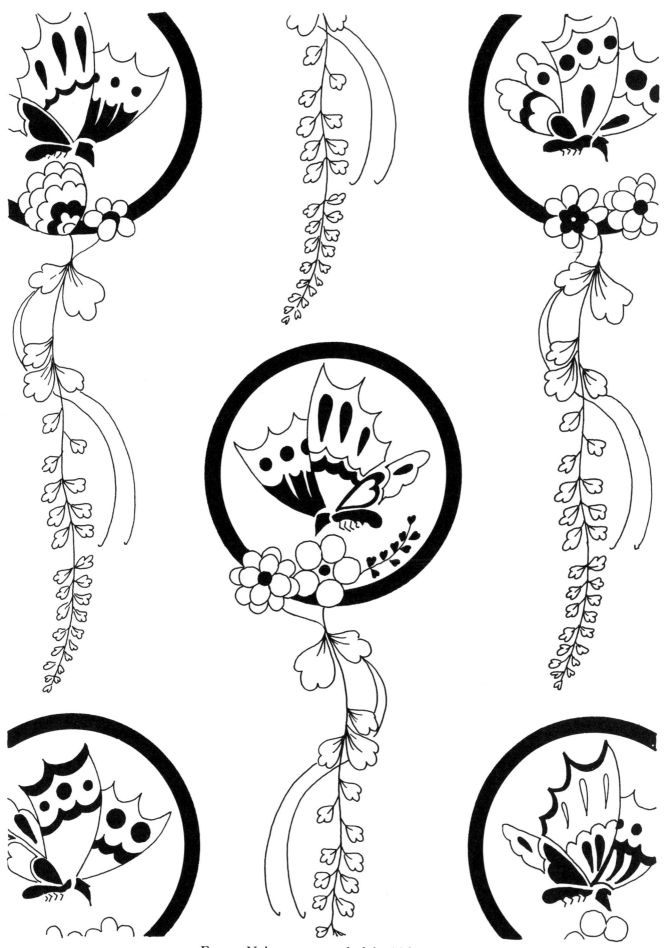

From a Noh costume, end of the 16th century.

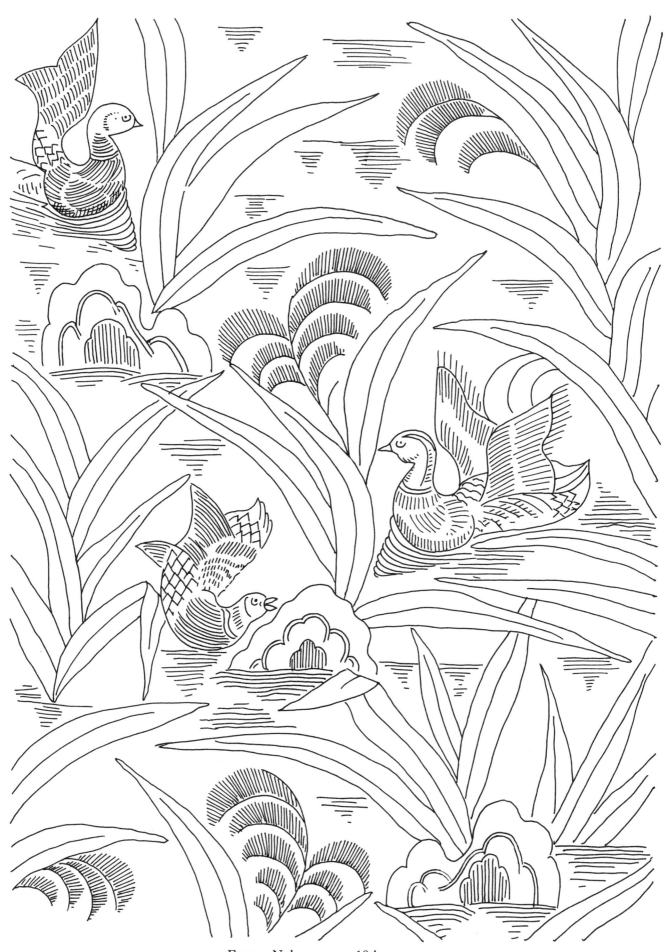

From a Noh costume, 18th century.

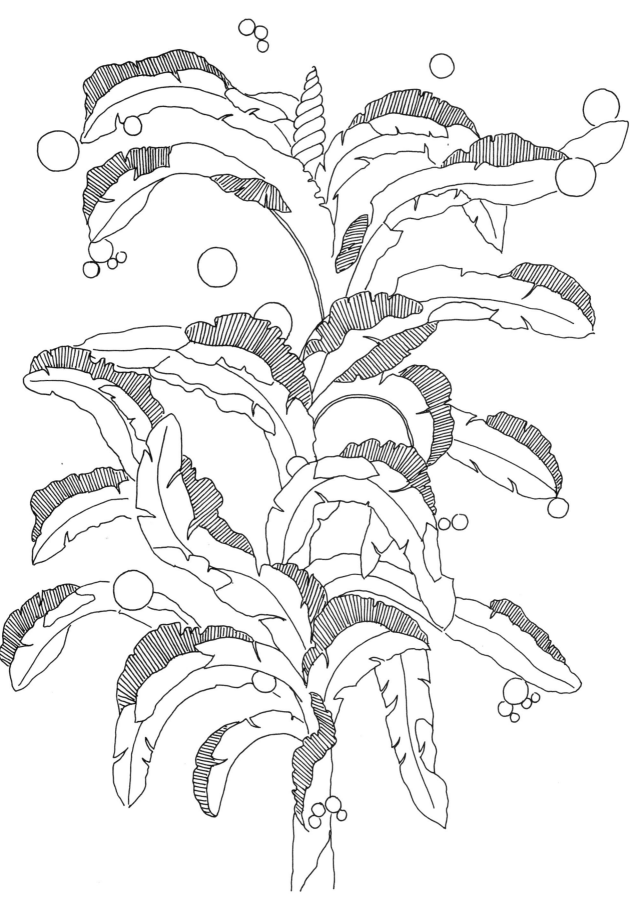

From a Noh costume, late 16th century.

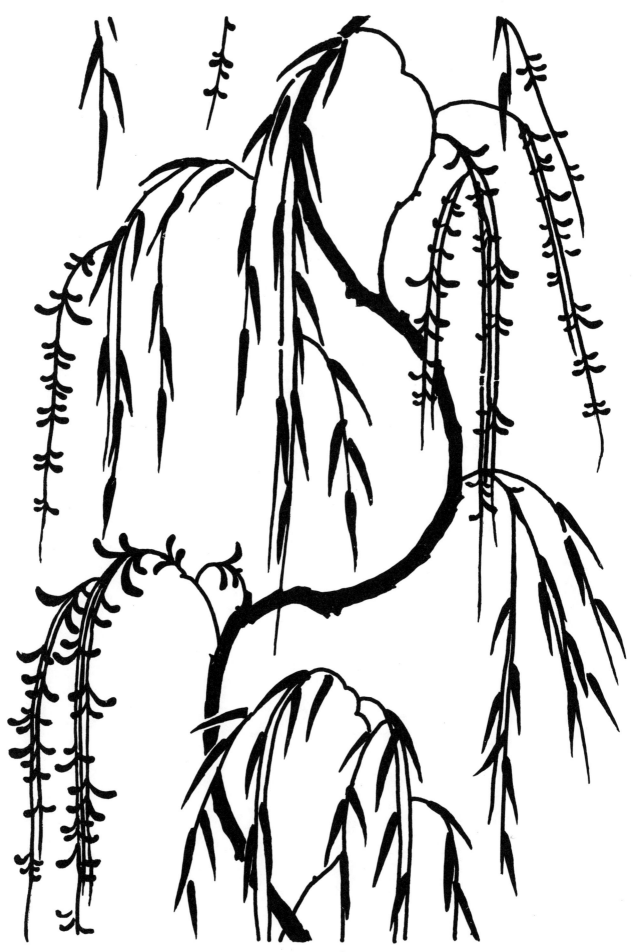

From a *kosode*, 18th century.

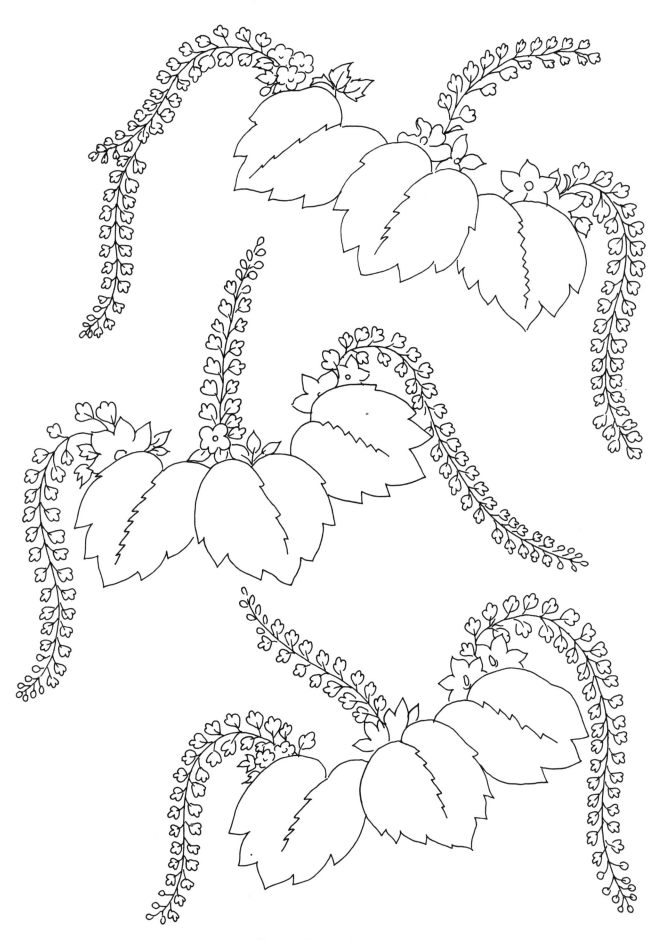

From a *kosode*, 17th century.

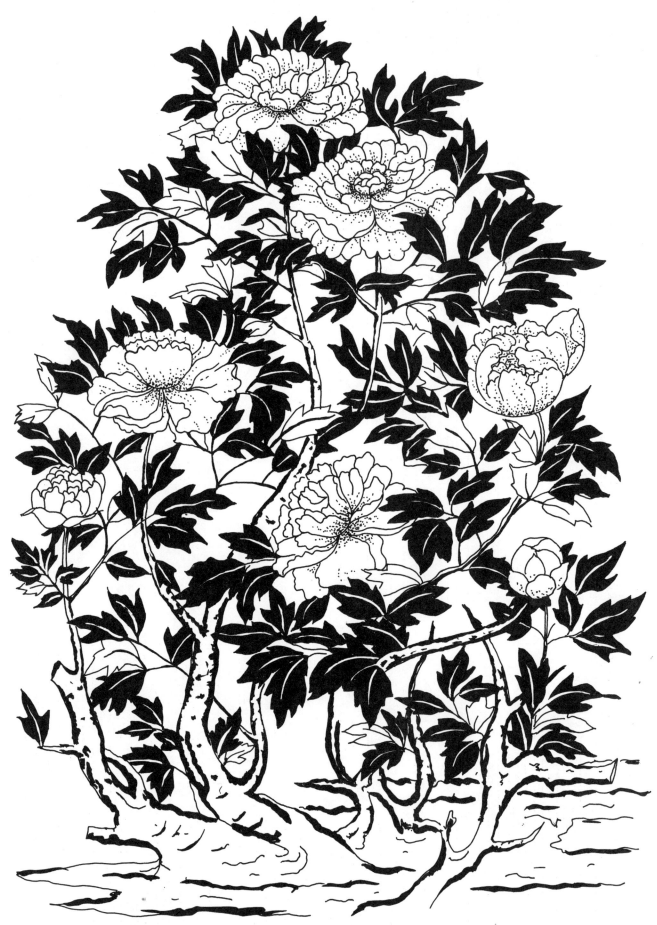

From a screen, 17th century.

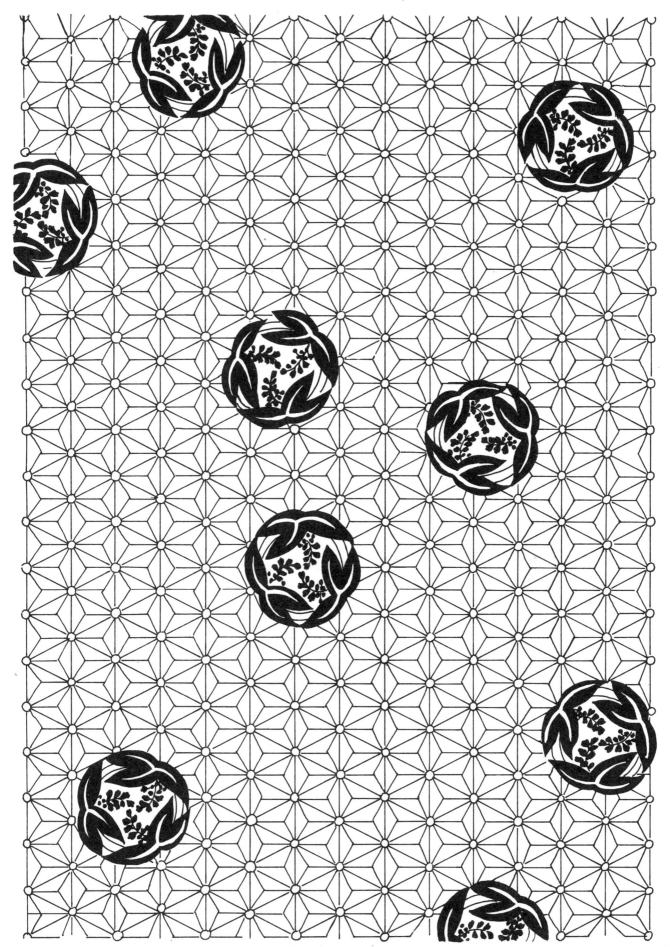

From a *kosode*, 19th century.

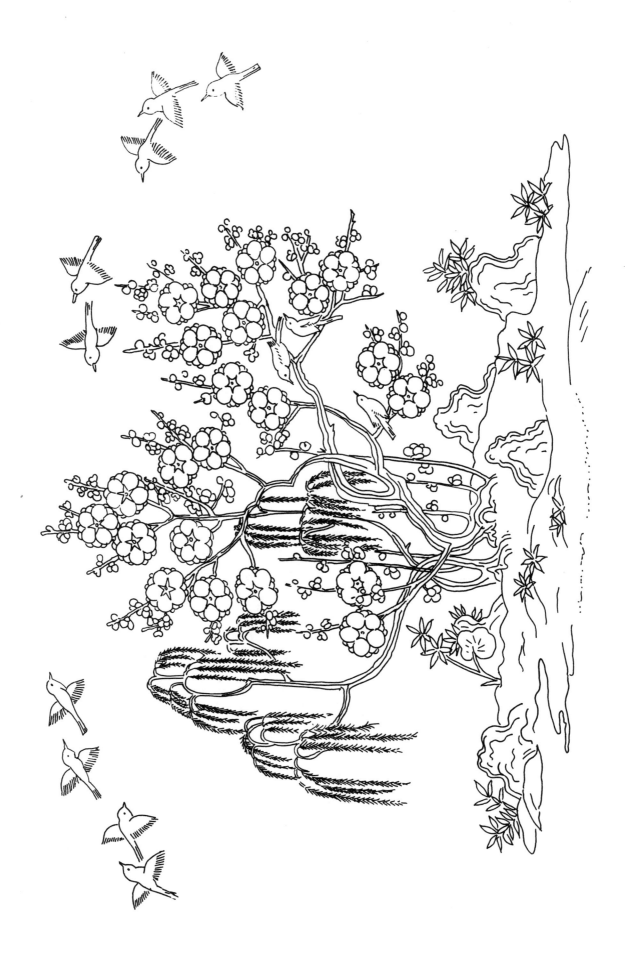

From a lacquer box, late 17th century.

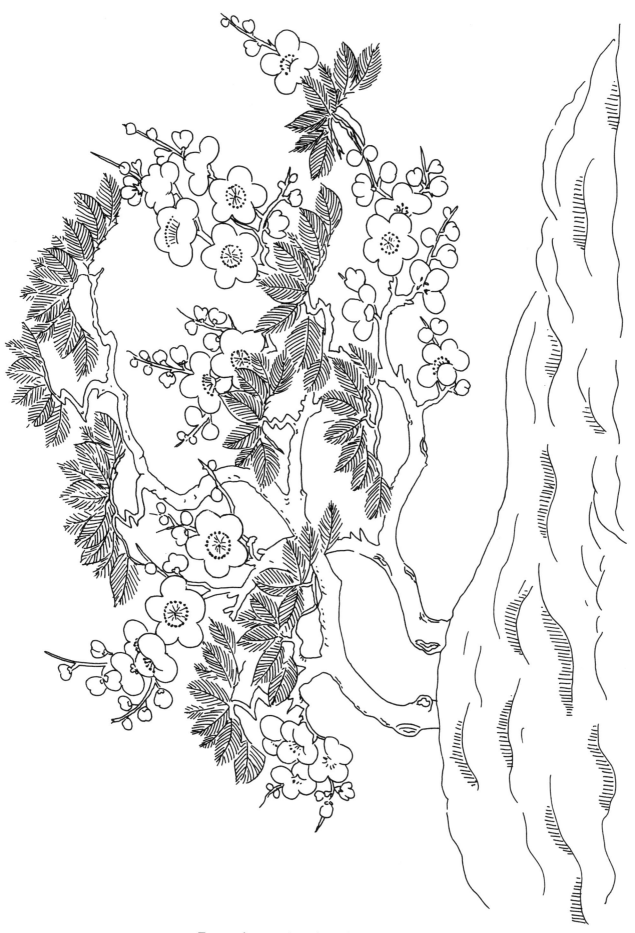

From a lacquer box, late 17th century.

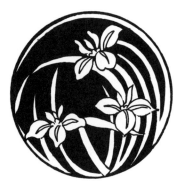
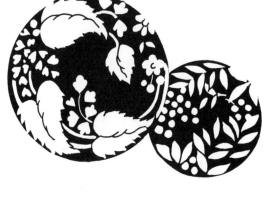

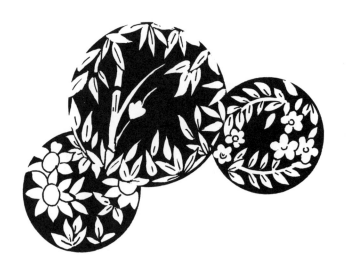
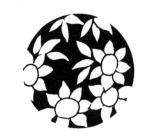
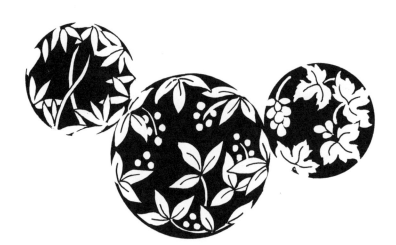
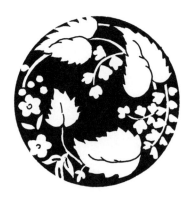

From a lacquer box, 18th century.

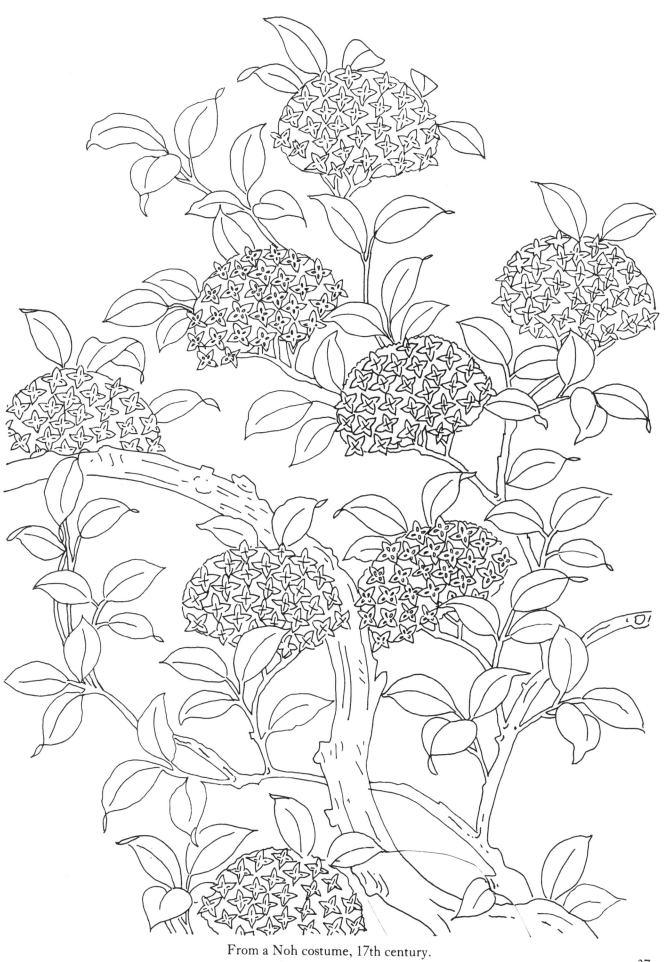

From a Noh costume, 17th century.

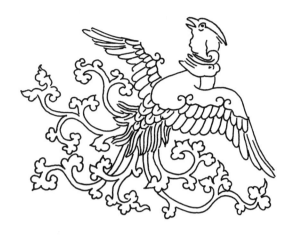

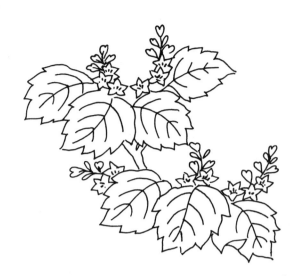

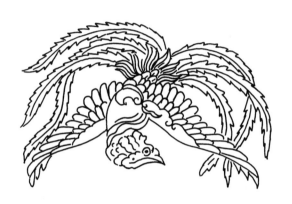

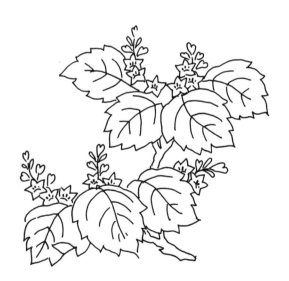

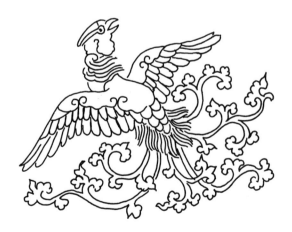

From a *kosode*, 19th century.

38

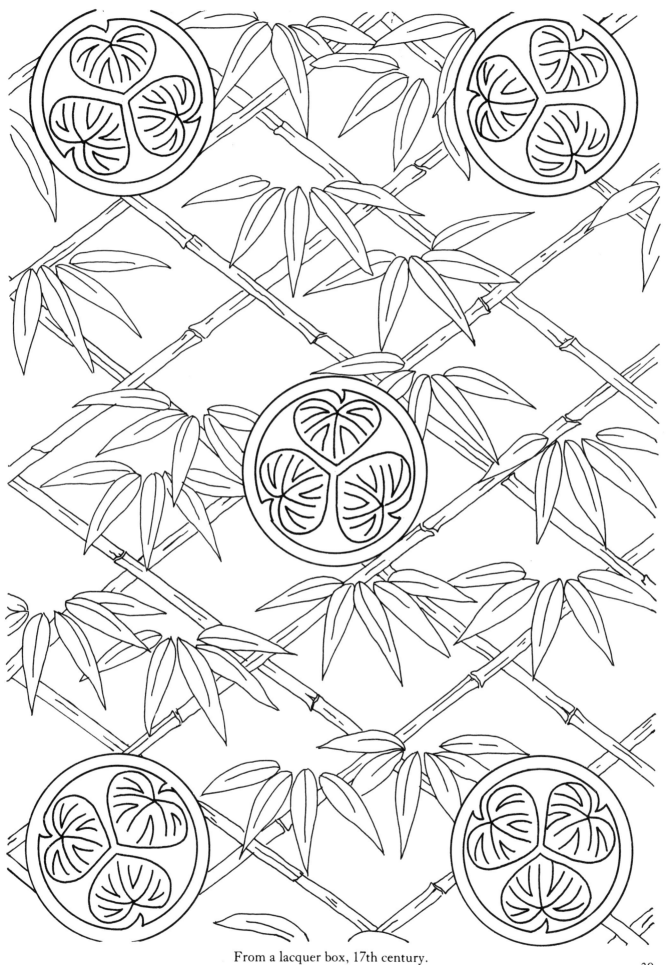

From a lacquer box, 17th century.

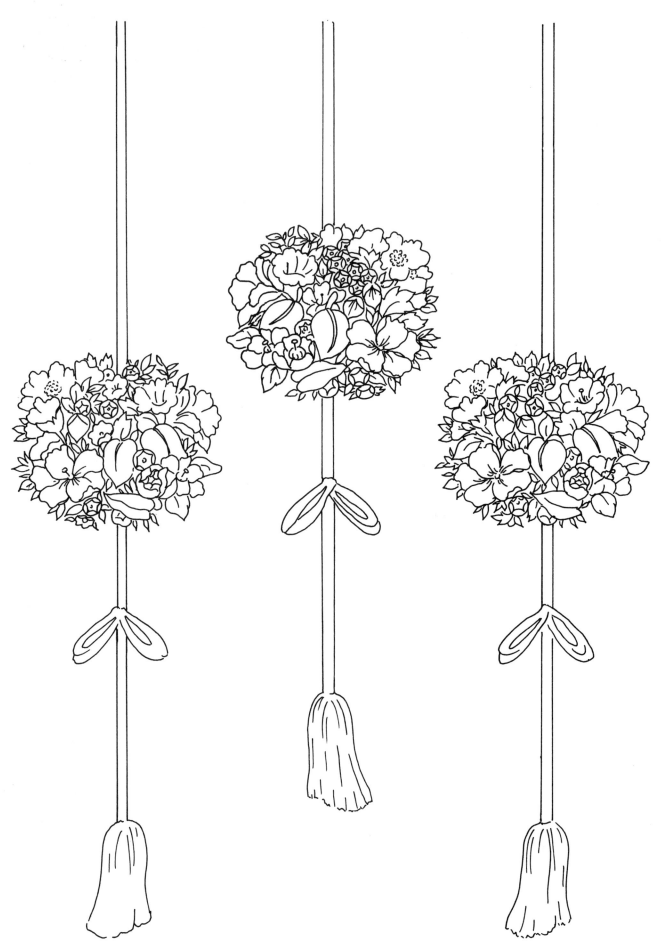

From a wall hanging, 18th century.

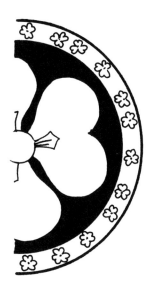
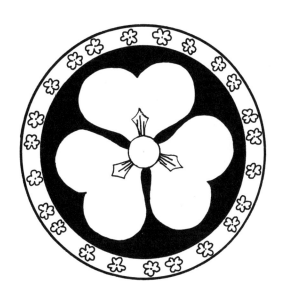
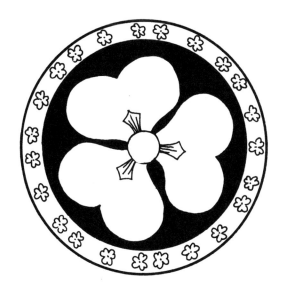
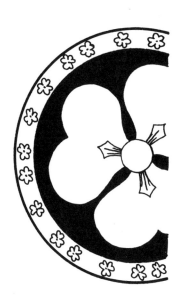

From a *kosode*, beginning of the 17th century.

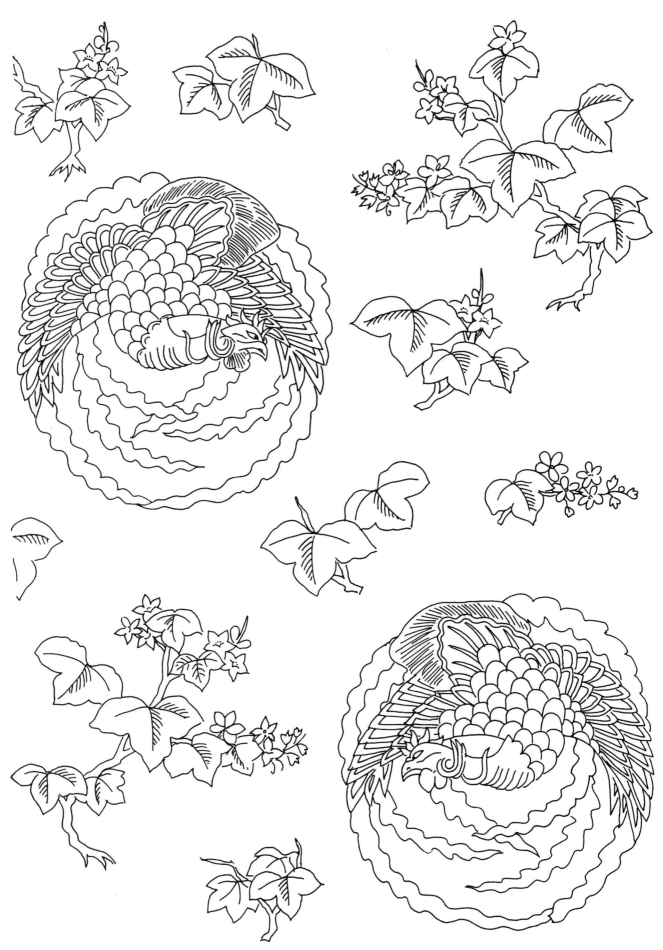

From a Noh costume, 18th century.

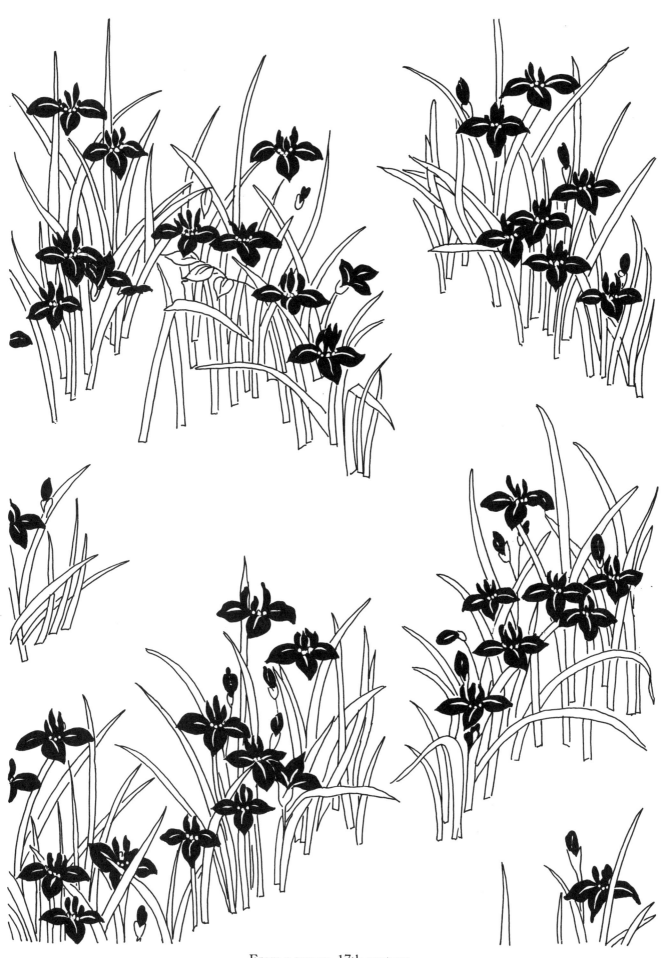

From a screen, 17th century.

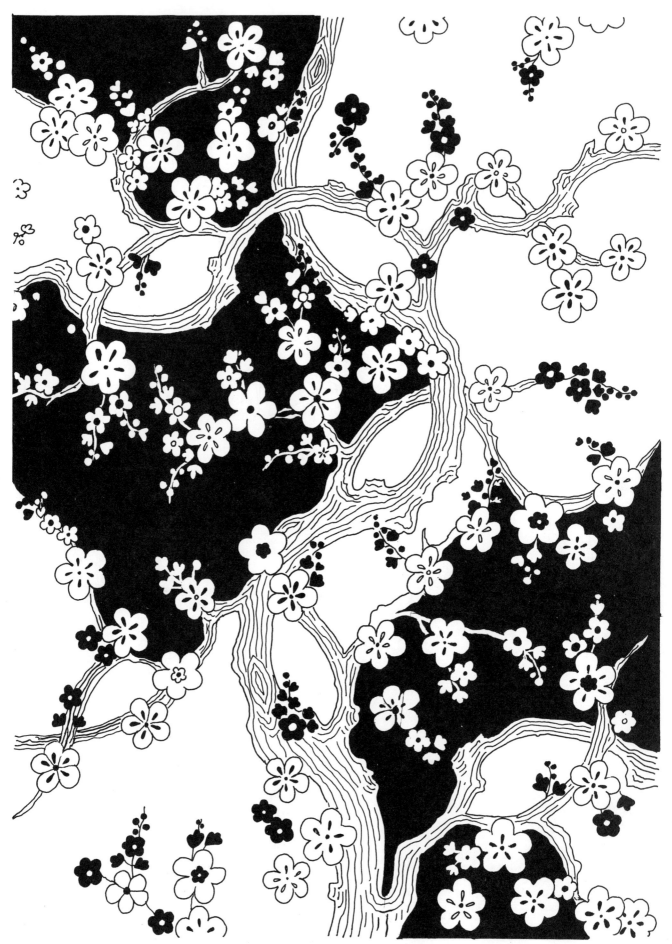

From a *kosode*, late 17th century.

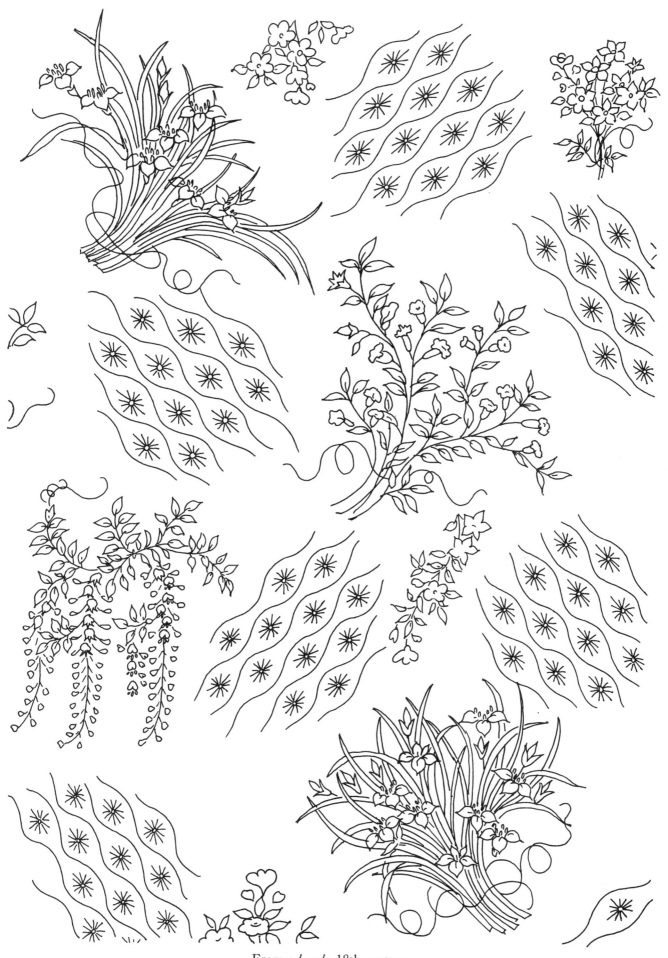

From a *kosode*, 18th century.

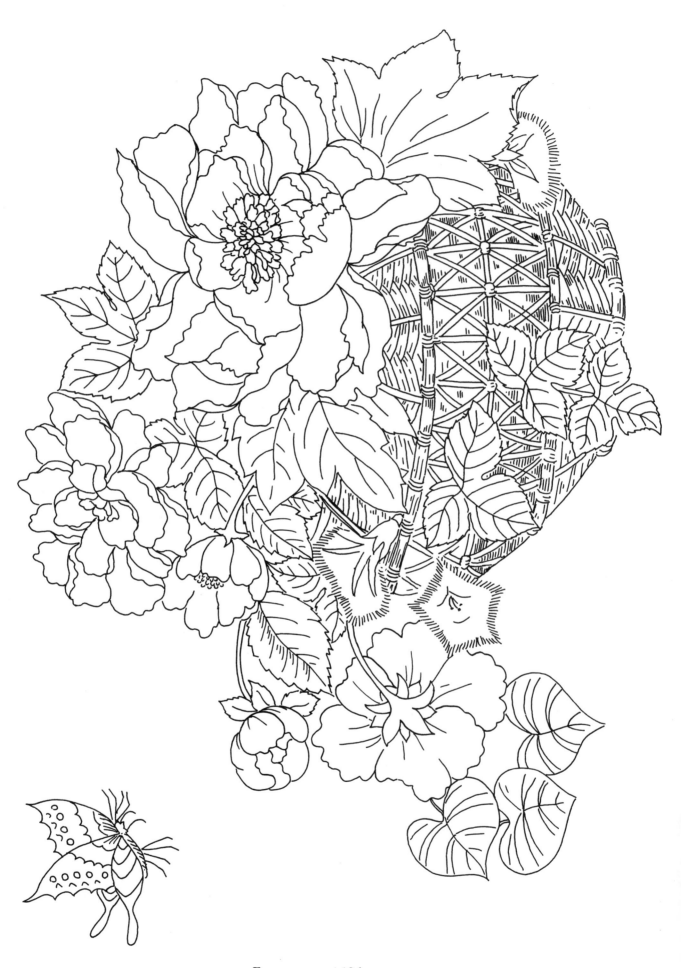

From a screen, 19th century.

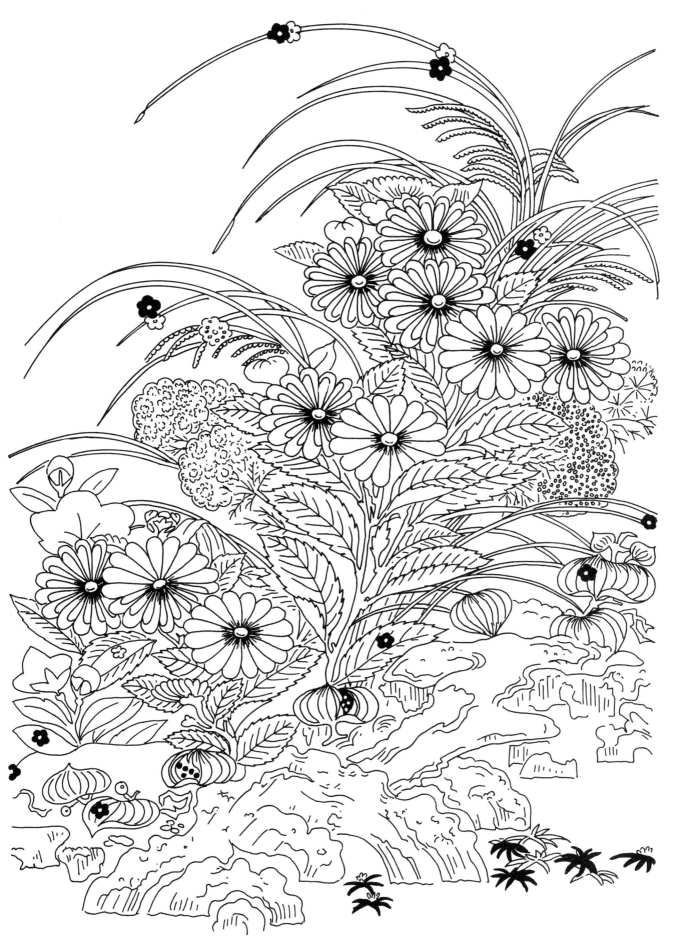

From a lacquer box, 19th century.

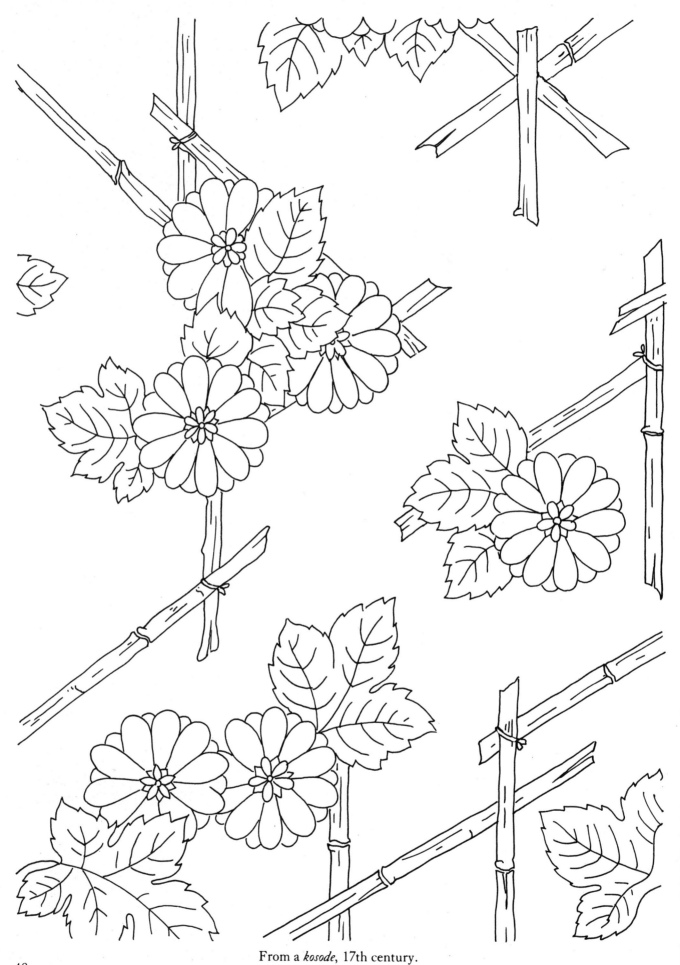

From a *kosode*, 17th century.